A WEEK SKETCHING IN THE
Galapagos

Sue Anne Bottomley

ISBN 978-1-950381-45-6

9 781950 381456

USA $19.95

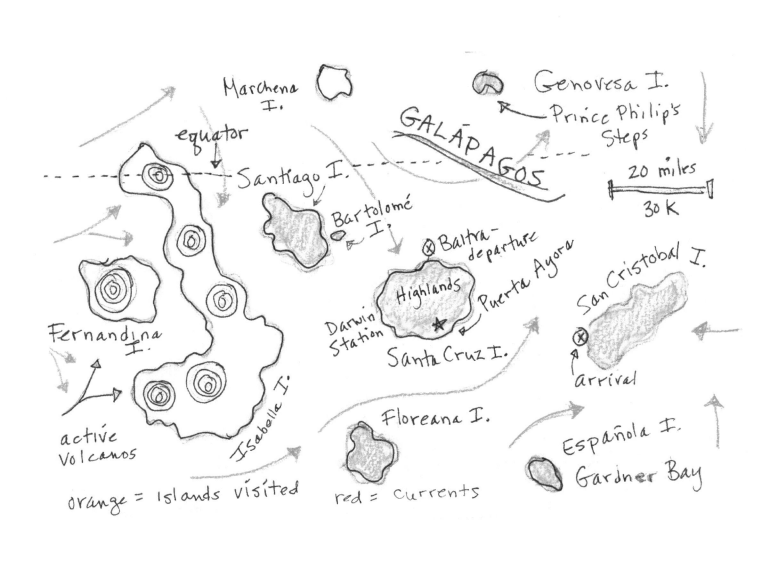

Marchena I.

Genovesa I.
Prince Philip's Steps

equator

GALÁPAGOS

Santiago I.

20 miles
30 K

Bartolomé I.

⊗ Baltra– departure

Highlands

Puerta Ayora

San Cristobal I.

Darwin Station

Santa Cruz I.

⊗ arrival

Fernandina I.

active Volcanos

Isabella I.

Floreana I.

Española I.
Gardner Bay

orange = islands visited

red = currents

INTRODUCTION

The nineteen major islands of the Galápagos archipelago are both old and new. The ones on the eastern side are older and slowly sinking into the sea. The larger islands on the western edge are still forming with twenty-one active volcanoes. Three tectonic plates meet and bump up against each other in this area. Beginning in the 1800s, humans have lived on five of the islands. Puerto Ayora, population 30,000, is the largest settlement.

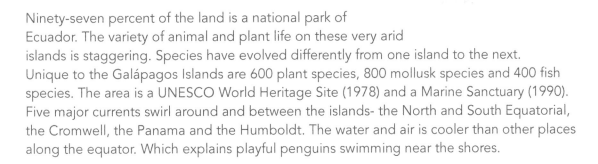

Ninety-seven percent of the land is a national park of Ecuador. The variety of animal and plant life on these very arid islands is staggering. Species have evolved differently from one island to the next. Unique to the Galápagos Islands are 600 plant species, 800 mollusk species and 400 fish species. The area is a UNESCO World Heritage Site (1978) and a Marine Sanctuary (1990). Five major currents swirl around and between the islands- the North and South Equatorial, the Cromwell, the Panama and the Humboldt. The water and air is cooler than other places along the equator. Which explains playful penguins swimming near the shores.

The islands were discovered in 1535 by a Panamanian bishop whose ship was blown off course. Ambrose Cowley, a buccaneer, gave most of the islands their English names. From 1831-1836, Charles Darwin was a naturalist on board the HMS Beagle during its second voyage around the world. He was a young man of 26 when he spent five weeks on the islands collecting rocks, plants, and animals. And observing and taking comparative notes on differences between one island and the next. Darwin wrote several books about his world-wide adventures, but didn't publish *On the Origin Of Species* until 1859. He especially noticed the modifications of bird beaks depending on the variety of food available on each island. He called this natural selection.

My facts above come from reputable online scientific sources. The book design replicates my sketchbook that I started and finished while on the islands, February 2019. And now, let's start our journey together.

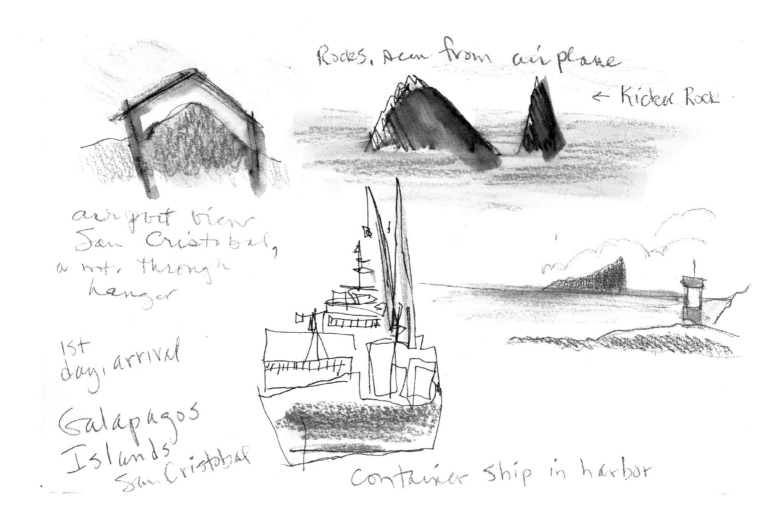

Rocks, seen from airplane

← Kicker Rock

airport view
San Cristobal,
a mt. through
hanger

1st
day, arrival

Galapagos
Islands
San Cristobal

Container ship in harbor

Our flight on Avianca Air from the mainland city of Guayaquil took a little less than two hours. We and our suitcases all boarded a bus for the very short ride to the dock in the town of Puerto Baquerizo Morento on San Cristobal Island. Our zodiac, a sturdy black inflatable boat, was waiting to take us to the ship.

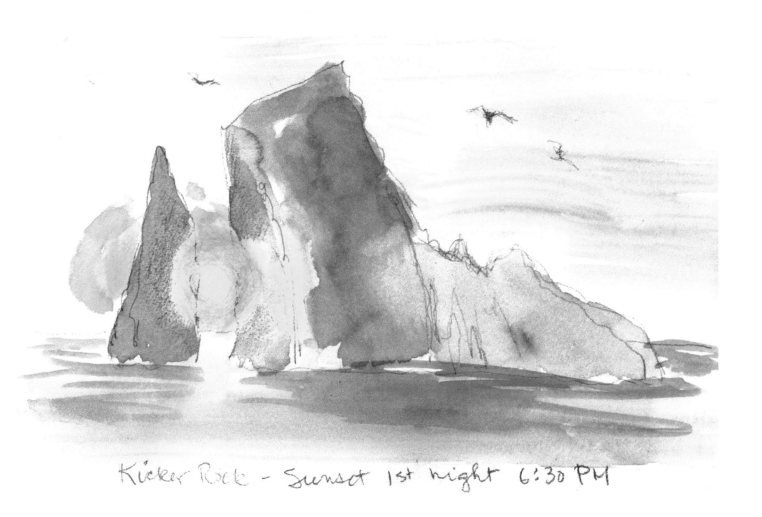

Kicker Rock - Sunset 1st night 6:30 PM

Most of the passengers, 90 or so, gathered on the top deck the first night to stand in awe of our first sunset. The ship was positioned exactly to squeeze the sun's last rays through the gap in the rocks. In Spanish Kicker Rock is called Léon Dormido, the sleeping lion.

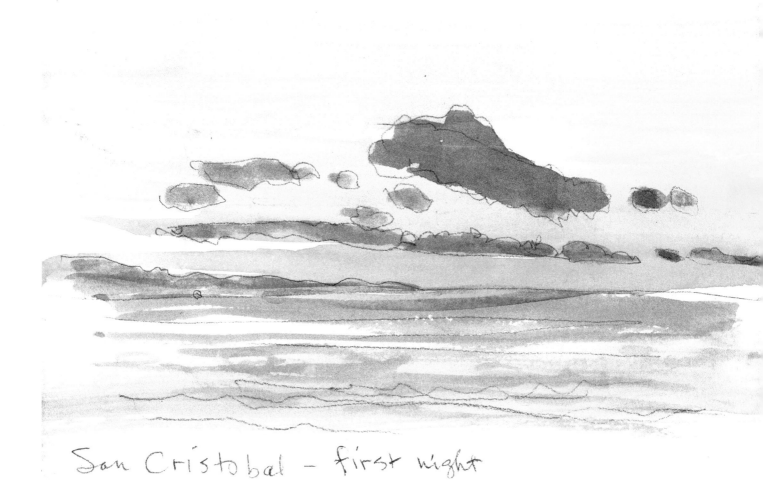

San Cristobal — first night

For this voyage, I brought a sketchpad of medium weight rough watercolor paper, my watercolor paint box, and a few brushes. I was already getting attention, such as "Ooh, we have an artist with us". I enjoy meeting people through my love of sketching.

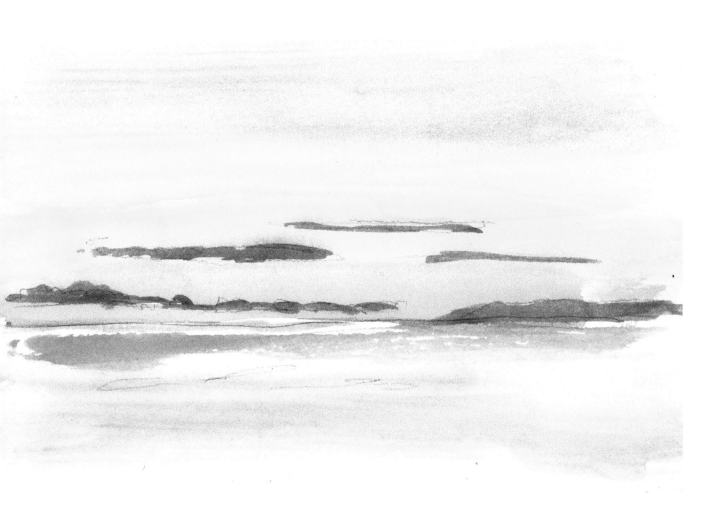

We all were loving the view, the colors, and the cool air. The next day we would learn about protecting ourselves from the equatorial sun. It requires a zinc-based sun block, long pants, long sleeves, a kerchief for the neck, sunglasses, and a broad-brimmed hat.

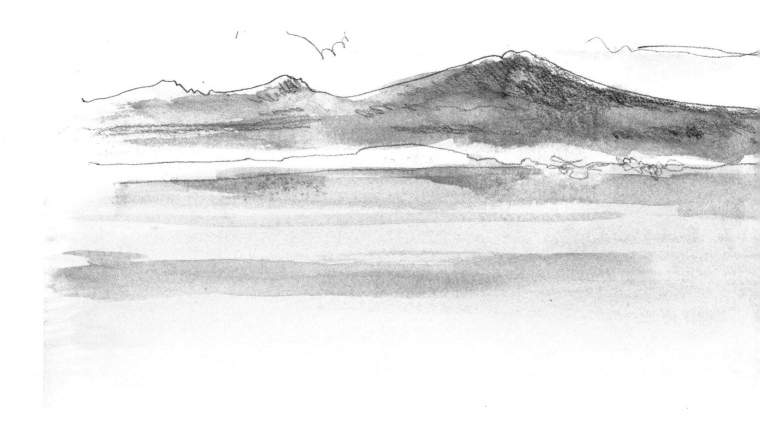

Española Island is formed of black volcanic rocks. The brilliant white sand beaches are created from ground up white coral and shells. The shifting light may explain the different colors on the low hills.

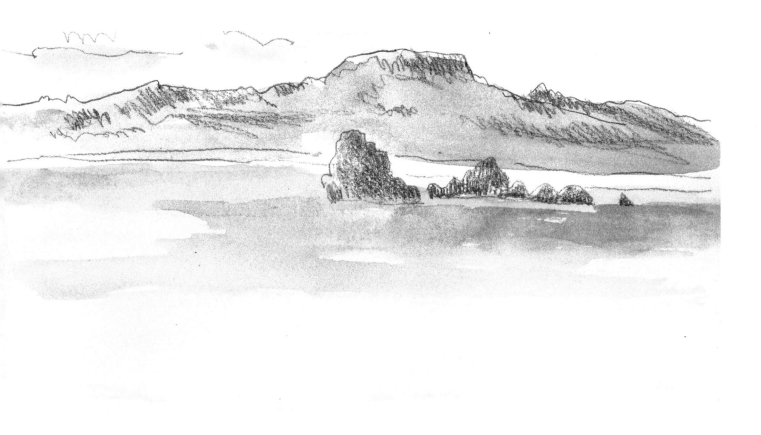

An on-board naturalist explained the black rocks/white sand phenomenon. Our guides and naturalists were locals, trained scientists, who could seemingly answer any question. Each had their area of expertise though, and they gladly shared it with us.

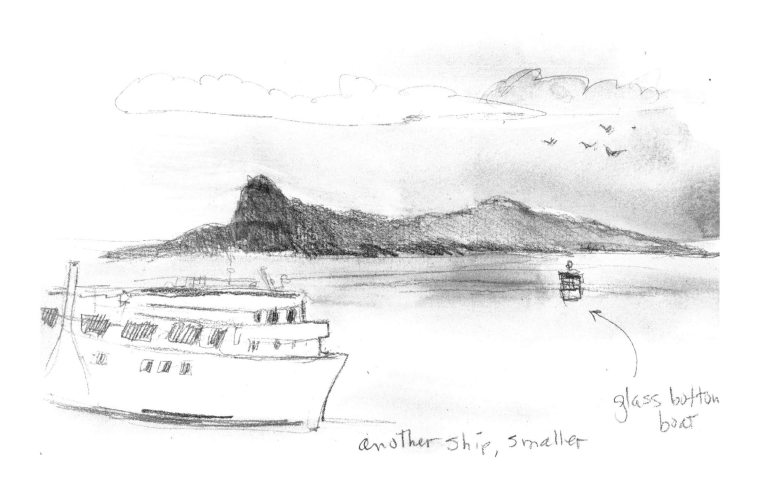

another ship, smaller

glass bottom boat

The distinctive shapes on the horizon captured my attention several times a day.
While waiting for my zodiac ride to the beach this day, I sketched this craggy, black lava
hill. The small glass bottom boat, on the right, works well for non-snorkelers like me.

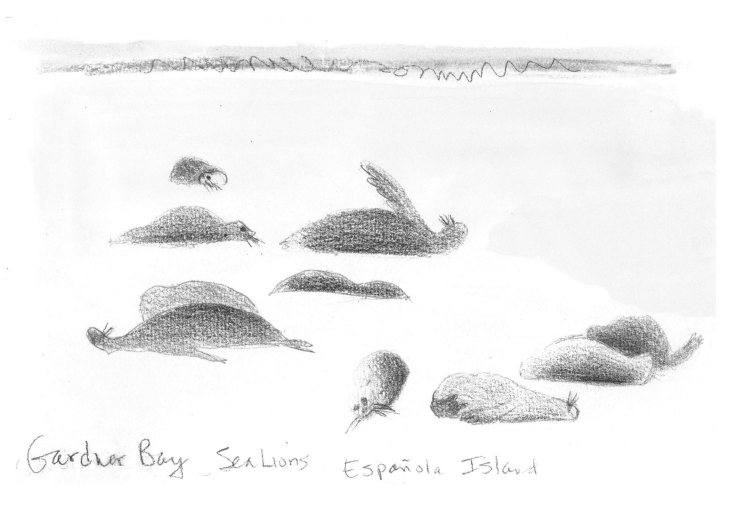

Gardner Bay Sea Lions Española Island

Our first off-ship excursion was a zodiac wet landing on Española Island. We all waded into the fine sand beach, full of sleeping sea lions. I sat down almost immediately with my paints and brushes.

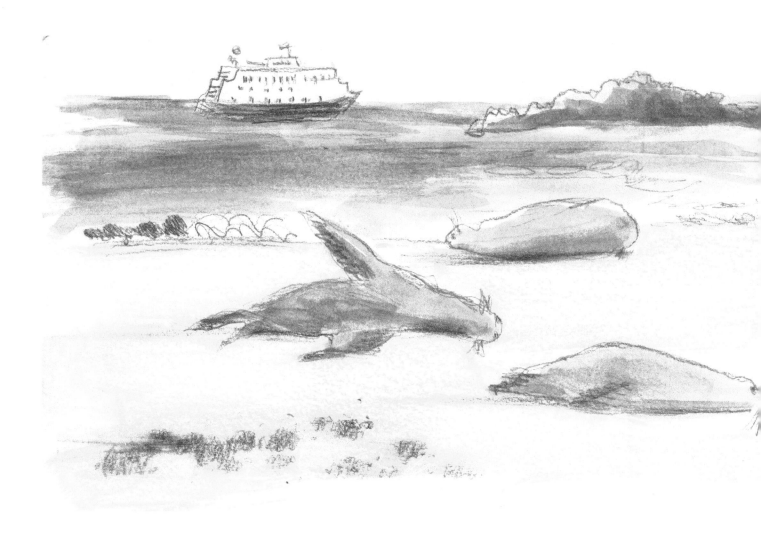

The tired out sea lions were sleeping after their busy morning catching their breakfast of fish, squid or octopus. They rolled in the sand, snorting and flapping at flies. They looked right at me, blinked, then rolled over and slept some more.

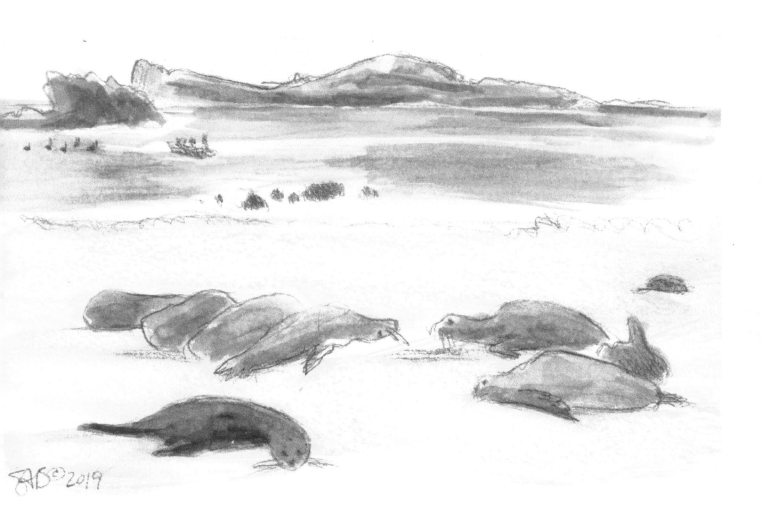

Sea lion pups get all their nourishment from mothers' milk for two years. I could hear the noisy gulping sounds of the nursing little ones. In the background, I painted the snorkelers and a guard zodiac in the blue and turquoise water.

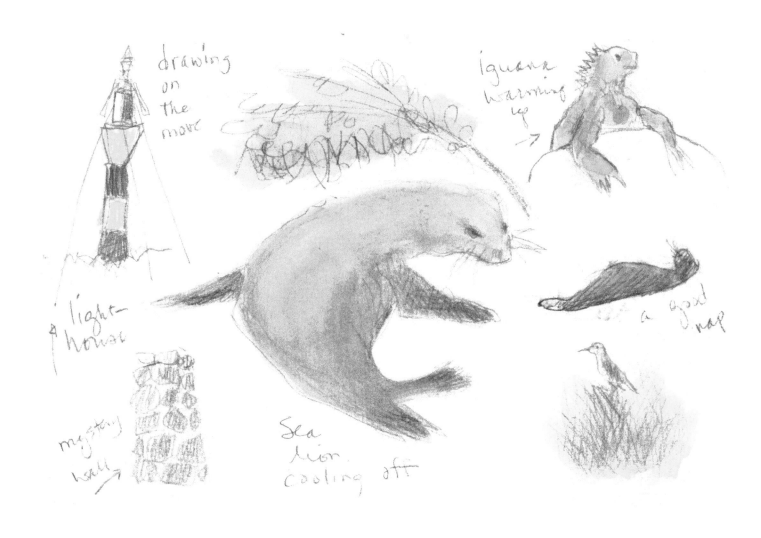

drawing on the move

iguana warming up →

light-house

mystery wall →

Sea lion cooling off

a good nap

On the other side of Española Island, our hike took us across sharp-edged brown rocks. We were totally dependent on our naturalist guide to tell us what we were looking at. The animals were abundant, and unfazed by close encounters with other species, including humans.

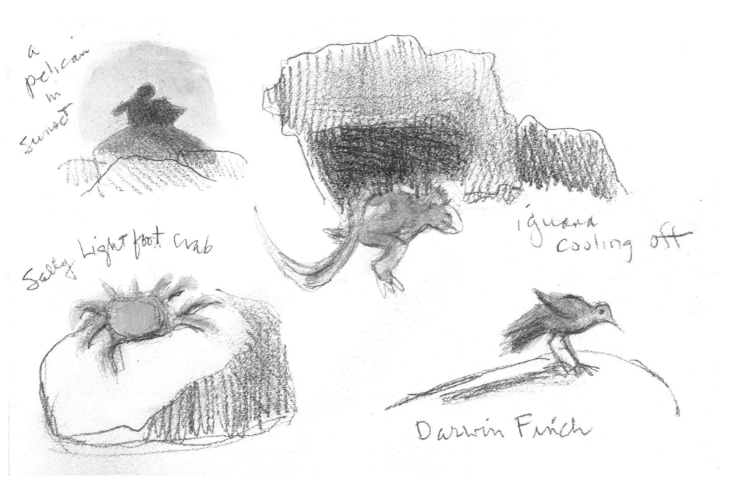

a pelican in sunset

Sally Lightfoot Crab

iguana cooling off

Darwin Finch

Fifteen different subspecies of marine iguanas live on the islands. They have evolved to swim to great depths to subsist only on seaweed. Some are black, and others are bright red and green (reflecting the colors of the seaweed) like this fellow in the shade of the black rock.

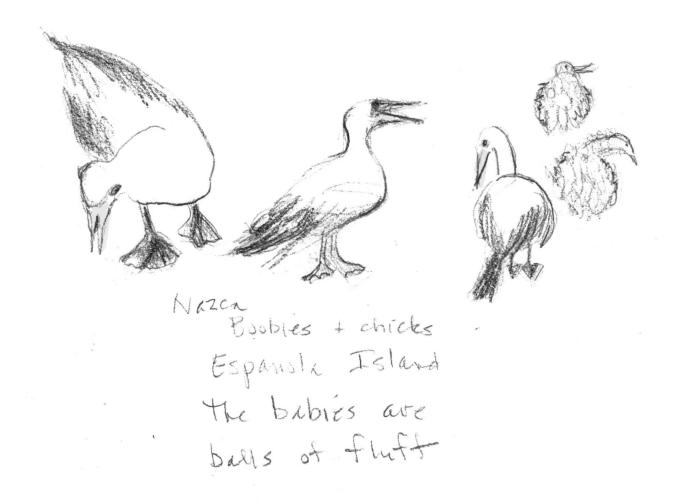

Nazca
Boobies + chicks
Espanola Island
The babies are
balls of fluff

On Española Island, we hikers encountered our first boobies. The parents, both with grey feet, care equally for their fragile offspring. A nest is a messy circle of rocks, right on the ground.

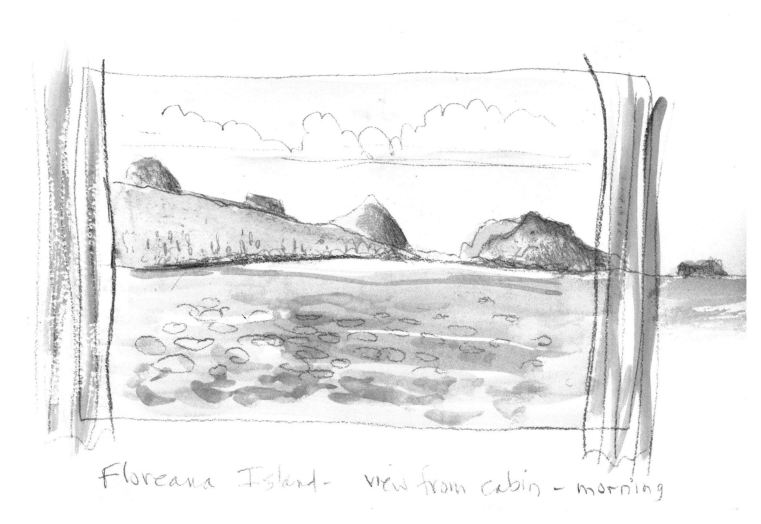

Floreana Island— view from cabin — morning

As the boat pivoted around on its anchor, my view out the cabin porthole changed within minutes. We went ashore on six islands, but many more exist and made for good sketching opportunities. The only way I could paint this view was while kneeling on the bed.

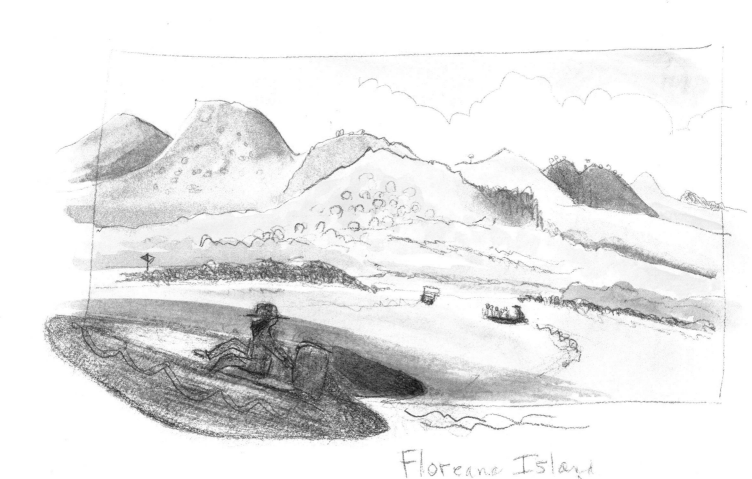

Floreana Island

Another paintable horizon popped into view with its round, tree-like cacti. The zodiac drivers protect their skin with kerchief masks and cotton gloves. It requires agility to get into the rubber rafts from the ship, and even more to get back onto them from the beach.

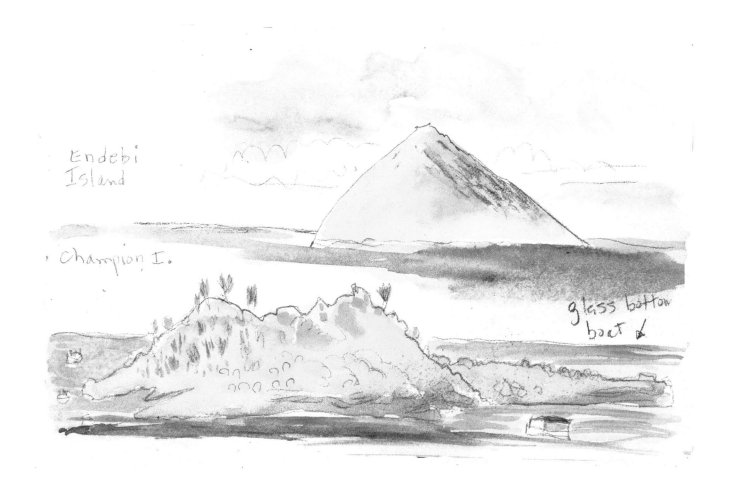

Endebi
Island

Champion I.

glass bottom
boat ↓

We didn't go ashore at either of these two islands, but many snorkelers from the boat marveled at the teeming undersea life. I believe it is known as one of the best sites for snorkeling. The cactus 'trees' are about 10-15 feet high, so you can see that the island is pretty small in scale.

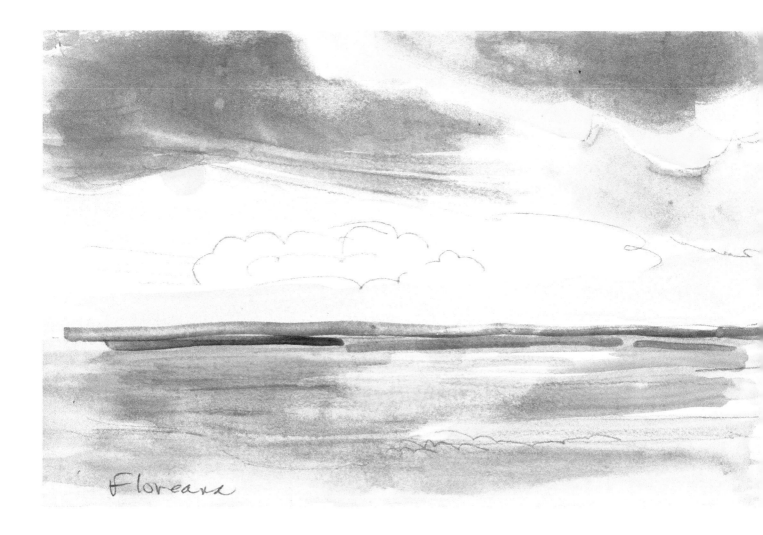

Floreana

In this scene, I was back to painting on the top deck again. The purple and yellow clouds floating above me were intriguing. I enlarged and darkened the rocks on the far right to visually balance out the large clouds on the left.

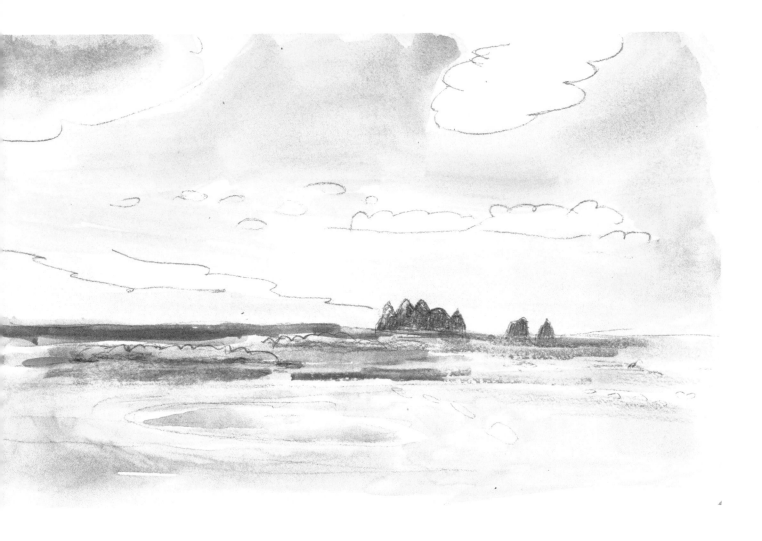

Floreana Island, population about 100, is on the right side of the painting. Notable facts are: the island has a pond that fills up during the rainy season, and flamingos can be seen wading in the shallow waters. Whalers set up a post office barrel here in 1793, and even today visitors can leave letters to be delivered by other visitors, or even pick up and deliver someone else's letter.

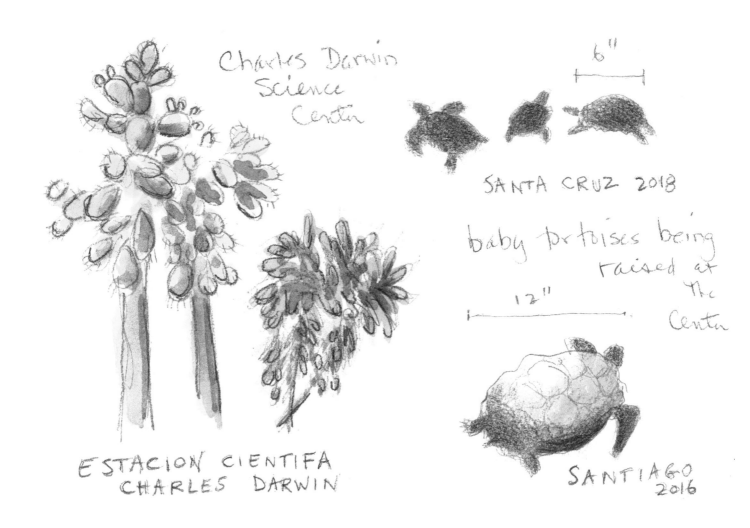

Charles Darwin
Science
Center

6"

SANTA CRUZ 2018

baby tortoises being
raised at
The
Center

12"

ESTACION CIENTIFA
CHARLES DARWIN

SANTIAGO
2016

The Charles Darwin Science Center lies on the outskirts of the town of Puerto Ayora on Santa Cruz Island. We learned about Lonesome George, or El Solitano Jorge, a giant tortoise who died in 2019 at over 100 years old. He was thought to be the last of his species from Pinta Island, but scientists have recently found a living relative.

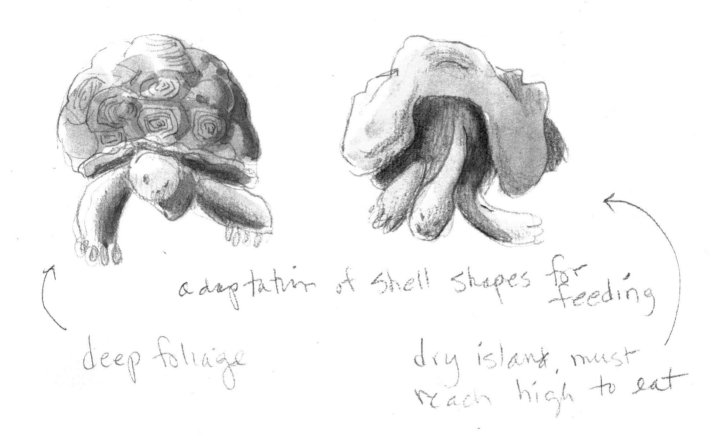

adaptation of shell shapes for feeding

deep foliage

dry island, must reach high to eat

After I read the sign explaining the different shell shapes of these giant tortoises, I pulled out my sketchpad. My tour group lost track of me and moved on. And I lost track of them entirely due to the focus and intensity that comes from on site sketching.

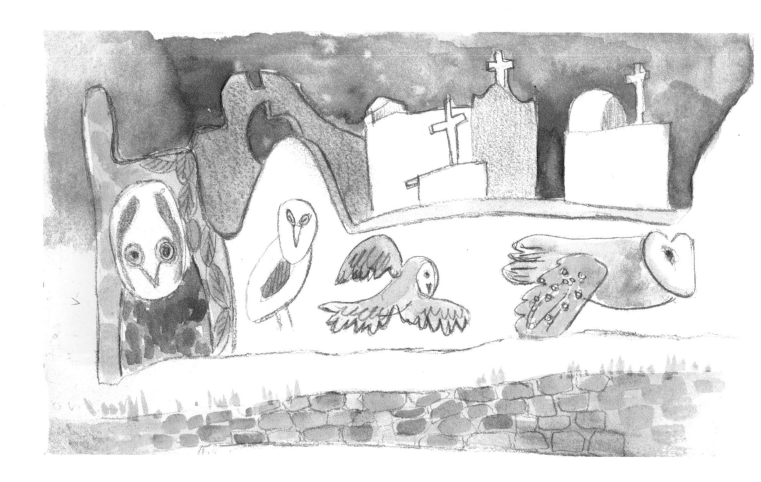

After our visit at the science center, we accepted a ride on a golf cart back to the center part of Puerto Ayora. When we passed this colorfully painted wall of the town cemetery, I hopped off and started my sketch. According to local beliefs, owls help transport our souls to heaven.

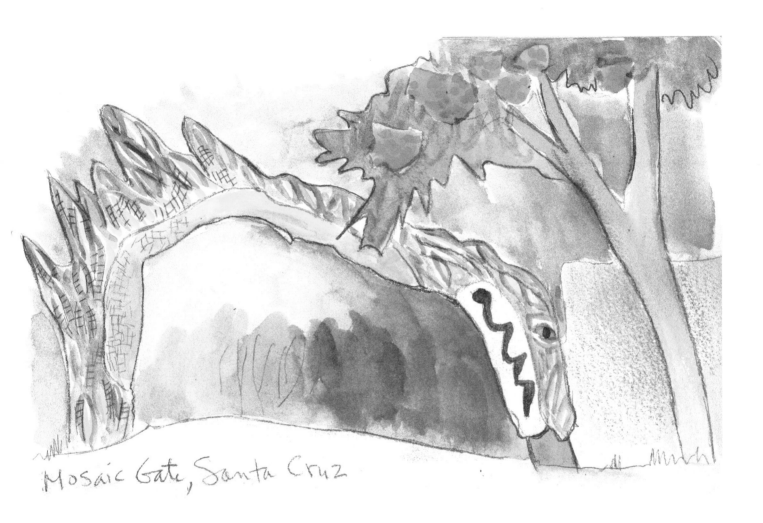

Mosaic Gate, Santa Cruz

Across the street from the cemetery, I discovered this 10-15 foot high mosaic gate. The day was broiling hot, I was in dire need of some water, and I couldn't figure out where my husband had gone. Nonetheless, I started sketching at the lower left and kept going until I got to the teeth and eye because I loved it so.

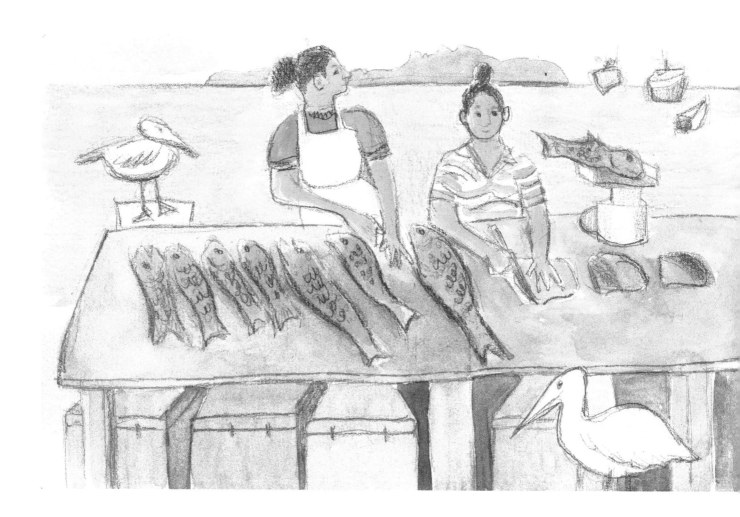

Sure enough, the small open air fish market in Puerto Ayora was a sight not to be missed. Organized chaos prevailed, with two vendors, a line up of strange looking Pacific Burrfish, crowds of tourists snapping photos, and locals buying fish. The tables and ice chests were all packed up by about noon.

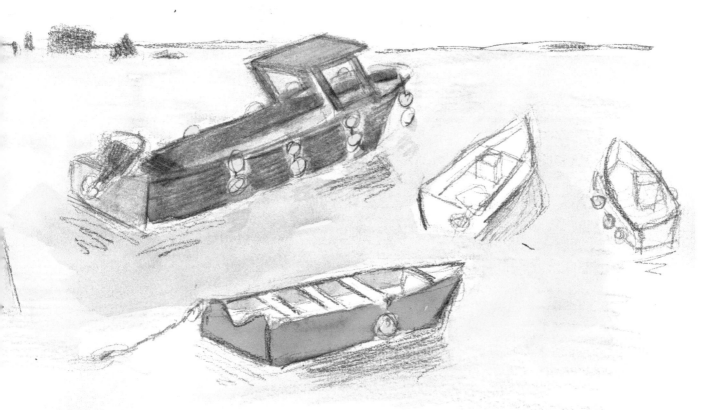

Fish Market Puerto Ayora, Santa Cruz Island

Flapping gulls, barking sea lions, and sneaky pelicans also hung out at the fish market, looking for scraps. Only a few boats were anchored in the turquoise waters of the harbor. After this drawing was finished, freshly squeezed thick blackberry juice quenched my thirst. At a nearby lively café.

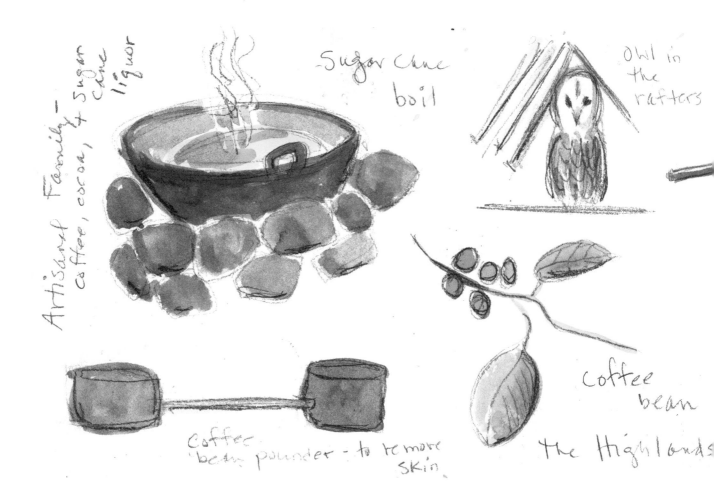

Artisanal Family – coffee, cocoa, & sugar cane liquor

Sugar cane boil

Owl in the rafters

coffee bean

the Highlands

Coffee bean pounder - to remove skin

After the juice break, most of my fellow passengers and I got on buses to ride a few miles uphill to a farm in the Highlands, an arable part of Santa Cruz Island. Some people tried out the sugar cane pressing wheel, while others tried a hand at roasting coffee beans. Coffee, grown and roasted in the Highlands, is the islands' biggest export.

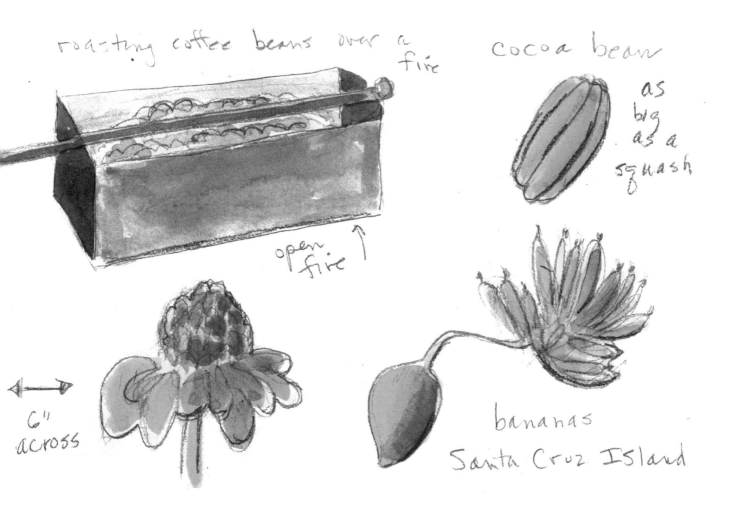

roasting coffee beans over a fire

cocoa bean

as big as a squash

open fire ↑

↔ 6" across

bananas
Santa Cruz Island

We guests at the farm (finca in Spanish) sampled a dark sweet sugar cane syrup poured over a feta-like homemade cheese. After one of our ship's naturalists taught us an Ecuadorian toast, we cautiously sipped the very strong sugar cane liquor. What wasn't consumed was then thrown into the open fire for fun explosive effects.

actual
Size

two bars
left on
our pillows
each night
on Ship

ANDEAN
ROSE
ESSENSE
CHOC BAR

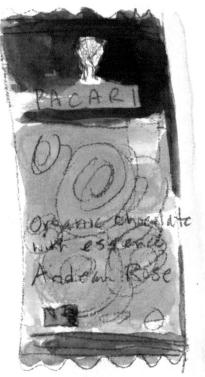

Rosa Andina

PACARI

Organic chocolate
with essence
Andean Rose

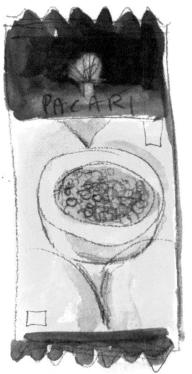

PACARI

Maracuya

PASSION FRUIT

When we returned to our cabins after each long, hot, fun, exciting, tiring day, we found neatly made beds and two chocolate squares on the pillow. Part of the fun of traveling is new foods and flavors. I read that the sun-drenched rich soils of Ecuador are perfect for cocoa bean cultivation.

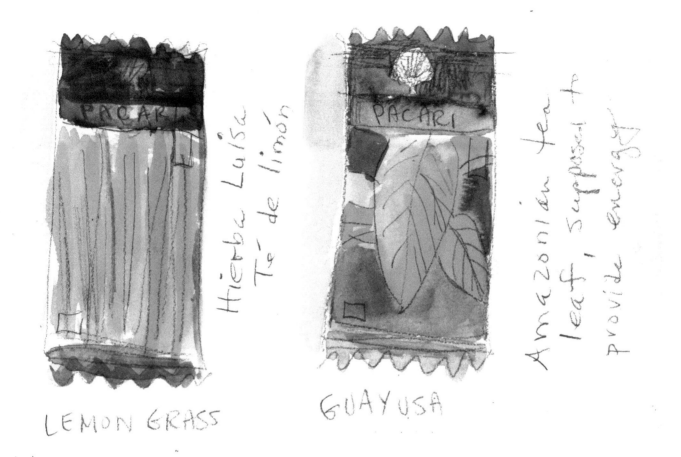

LEMON GRASS

Hierba Luisa
Té de limón

GUAYUSA

Amazonian tea
leaf, supposed to
provide energy

Cocoa beans are grown and processed in the Galápagos and on the mainland.
Ecuadorian chocolate has won many international awards, even beating out
Switzerland.

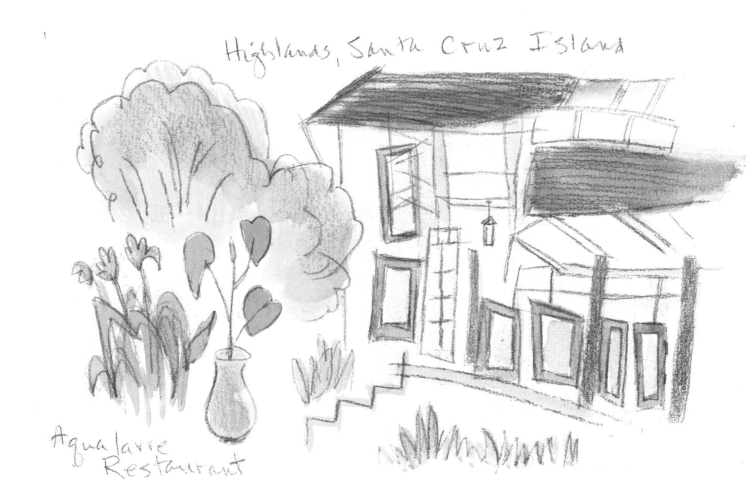

Highlands, Santa Cruz Island

Aqualarre Restaurant

After our morning of sampling syrup, cheese and liquor, it was time for lunch.
One bus group enjoyed our delicious chicken, potatoes and veg on an outside
covered patio. The rest of our bus group ate indoors, but surrounded by paintings,
sculpture and colored glass bottles.

tropical flowers - a treat to see in Feb.

ginger flowers (?)

Hibiscus on the table

Al Fresco lunch

Sketching after lunch in the garden

The Chilean owners of the Aqualarre Restaurant have been feeding hungry tourists in their home for twenty years. I got a personal art tour after showing my sketchbook to the owners. Sketching breaks down barriers every time.

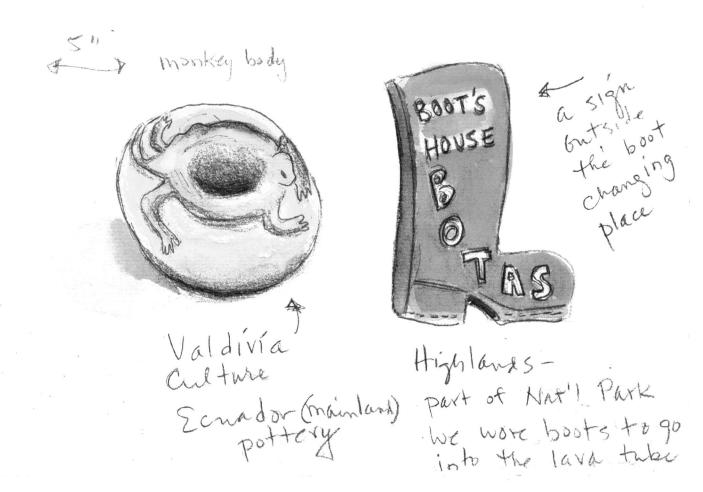

←5"→ monkey body

BOOT'S HOUSE BOTAS

← a sign outside the boot changing place

Valdivia Culture
Ecuador (mainland) pottery

Highlands —
part of Nat'l Park
we wore boots to go
into the lava tube

The owners then invited me upstairs to see their enormous pottery collection. I drew one small donut-shaped pot with a monkey carved into the clay. It was perhaps made between 3500-1800 BC. Gosh.

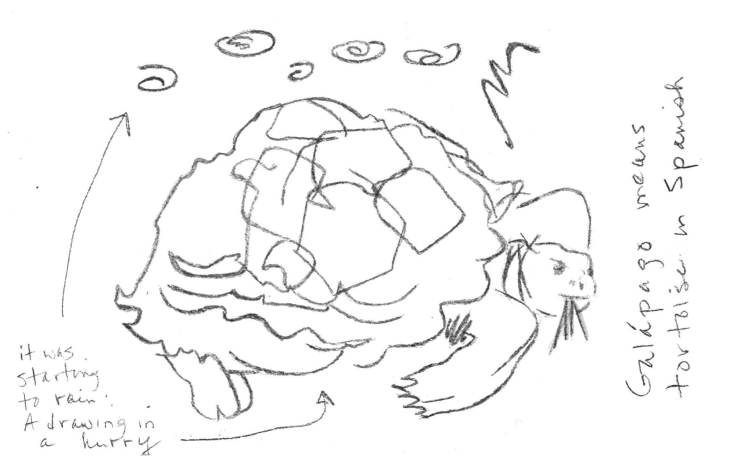

it was starting to rain. A drawing in a hurry

Galápago means tortoise in Spanish

After lunch and the art tour, it was time to travel even farther uphill to find the 600 pound giant tortoises at the Santa Cruz National Park. It is thought that the huge beasts, who live to be 150 years old, got caught up on floating masses of plant material debris from the mainland two or three million years ago. And then each species evolved to best meet the conditions on their islands.

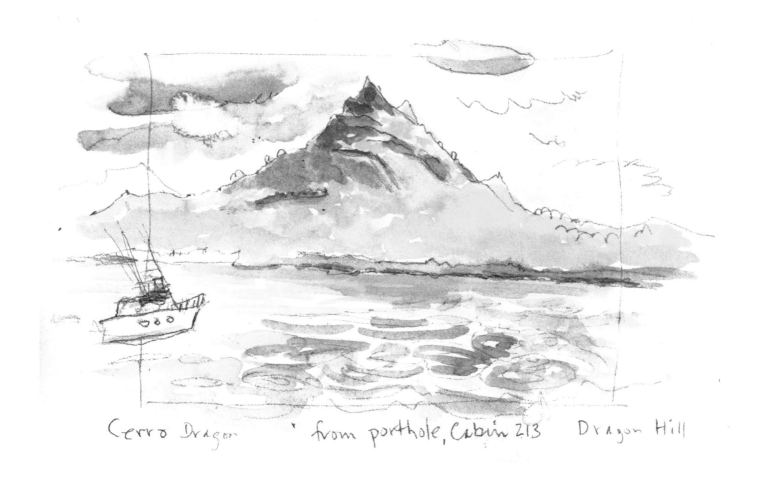

Cerro Dragon from porthole, Cabin 213 Dragon Hill

I sketched then painted this view from the cabin porthole, and then walked a few
yards to the reception desk to ask the name of the island. Sometimes I learned a bit
of Spanish in the process, like 'El Cerro' means the hill. I didn't mind cloudy days, as
it meant cooler temperatures.

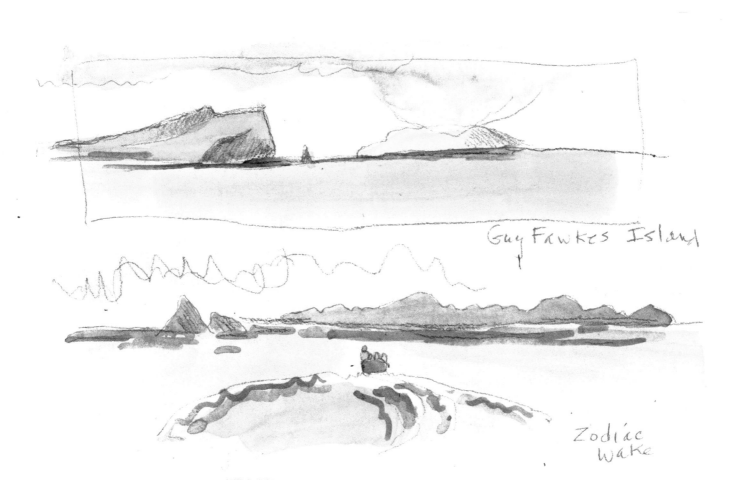

Guy Fawkes Island

Zodiac Wake

Most of the islands have English and Spanish names, but not Guy Fawkes Island. I didn't go on every on-shore excursion. Sometimes I stayed on the ship to finish a painting or visit the gift shop, library, or snack bar.

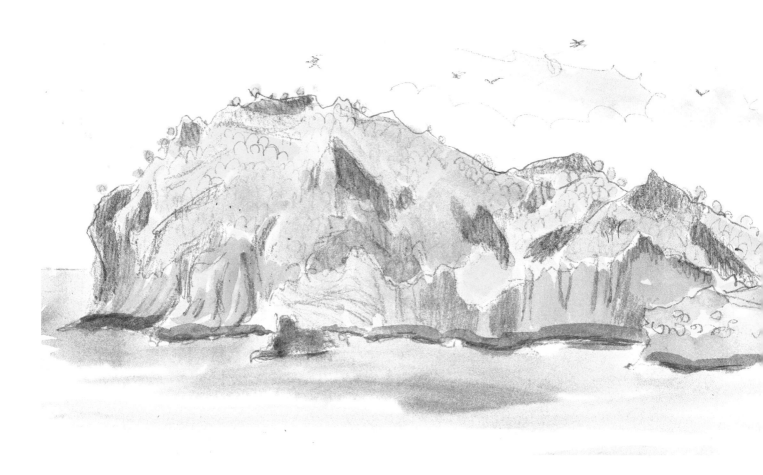

The ship circled El Edén late in the day, but we didn't have any excursions to it. The small island of 2000 square feet, off of Santa Cruz, is an eroded tuff cone formed when molten lava hits the cold sea water. Snorkeling is excellent, so they say.

And a few more facts about the amazing Galápagos Islands. The colors of the sand beaches are red, gold, white, green, black, and pink. As well, 42% of plants, 79% of mammals, 80% of birds, 91% of reptiles, and 50% of insects are unique to these islands alone.

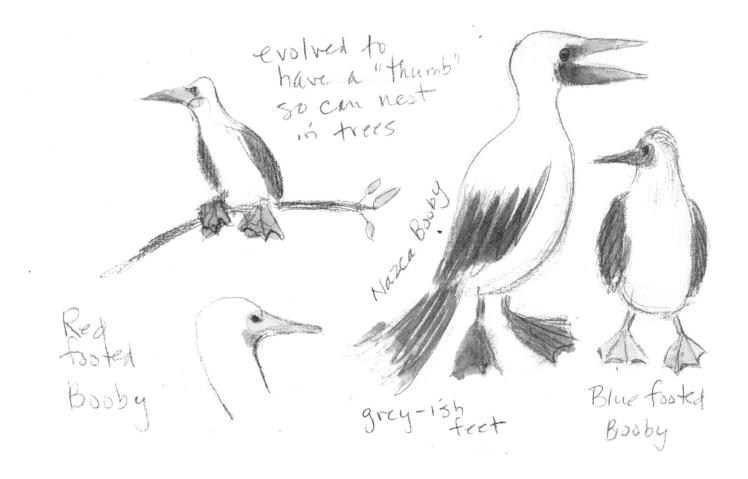

evolved to
have a "thumb"
so can nest
in trees

Nazca Booby

Red
footed
Booby

grey-ish
feet

Blue footed
Booby

I'll just say right off the bat that I only saw blue-footed boobies at a distance from Bartolomé Island. On Genovesa Island, red-footed boobies and nazca boobies (grey footed) are abundant and nesting right next to the footpath. The birds are busy attending to their babies, and ignore everything else.

needed binoculars!

Short Ear Owl

Small asymetrical ears.

rocks ↓

exactly the same color as the volcanic rocks

↑ dead bird lunch

LAST DAY

GENOVESA ISLAND

SUNKEN VOLCANO, boat anchored in the caldera. → Prince Philip steps- steep!

The top of Genovesa Island is rocky, flat, treeless, and teeming with birds. We did spot one owl on the rocks. Judging from our guide's excitement, it's a rare sight. Staying on the footpath as instructed, we were sometimes still within two or three feet of a nesting boobie family.

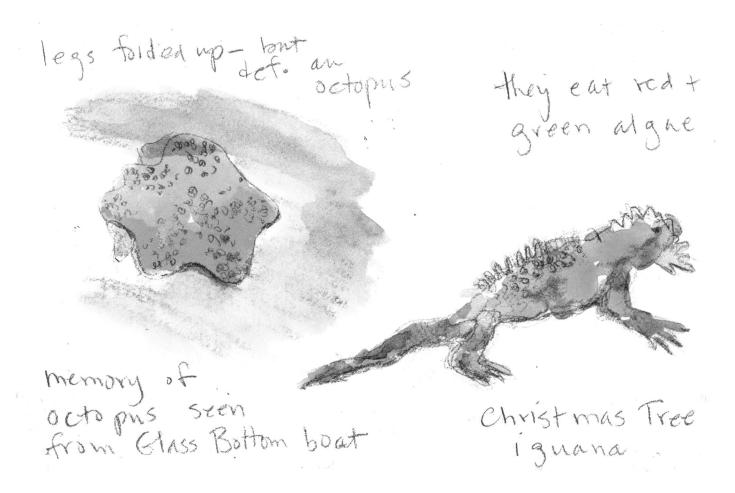

legs folded up — but
def. an
octopus

they eat red +
green algae

memory of
octopus seen
from Glass Bottom boat

Christmas Tree
iguana

The iguanas were all sunning themselves and keeping very still. When I passed by, they would slowly turn their heads and blink. Several times I saw them clear their noses of seawater by snorting it out in a big spray.

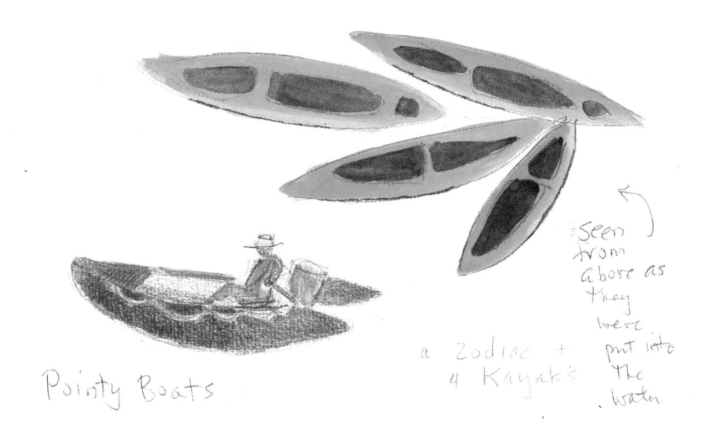

seen from above as they were put into the water

Pointy Boats

a Zodiac + 4 Kayak's

The kayaks and zodiacs are lifted into the water from storage on the top deck of the ship. The kayakers of the day were about to paddle off to view the flamingos in the shallows of Floreana Island. I am more of a lake kayaker than an open sea one.

I love children's art + am often inspired by it.

paint on concrete

The young people's artwork on the side of their skate park pulled me in. So well painted, large and bold. I hadn't seen all of these sea creatures in Galápagos, but I have been lucky enough to set eyes on them in other places, like Polynesia.

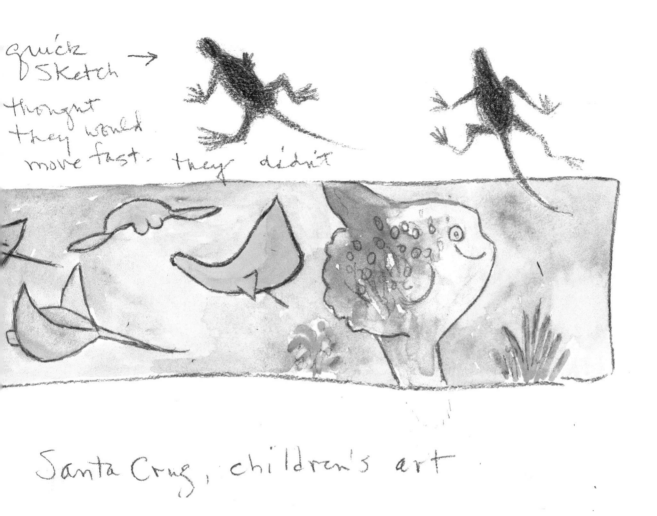

quick
sketch →

thought
they would
move fast. they didn't

Santa Cruz, children's art

The enormous grey fish painted on the wall is an ocean sunfish, called mola mola in scientific terms. It can weigh up to 2000 pounds, lacks a tail fin, and is fortunately not aggressive. It happily allows 'cleaner fish' and even sea gulls to help clear its skin of parasites.

Great Blue Heron

Cattle Egret

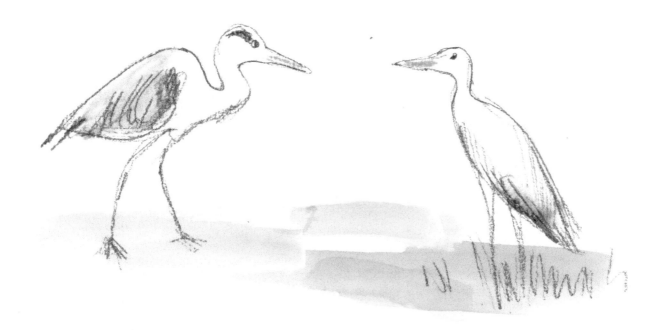

We saw a few of these beautiful birds while on Santa Cruz Island. The herons prefer the wetter areas, while the egrets quietly and gracefully strut through the meadows.

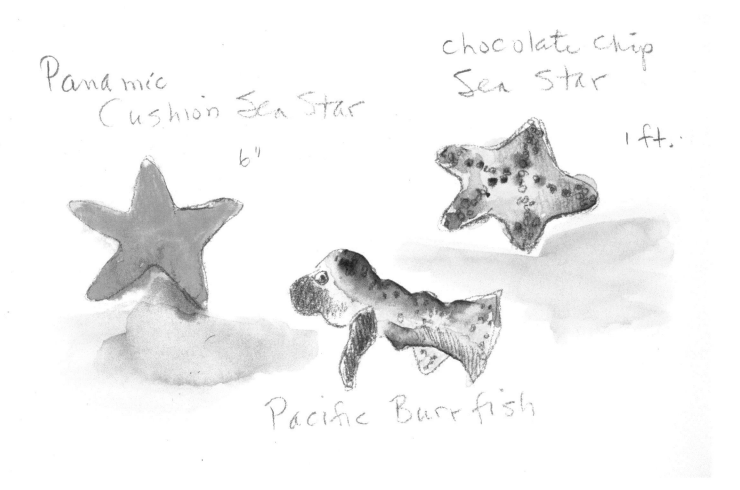

Panamic
Cushion Sea Star
6"

chocolate chip
Sea Star
1 ft.

Pacific Burrfish

Sea stars and Burrfish are some of the sea creatures we spotted from our glass bottomed boat. Or the 'GBB' as the staff on the ship called it. Starfish have been renamed as sea stars because they are not fish.

Frigate Bird

King Angelfish

You never forget seeing a group of frigate birds. Their gullar sacs are bright red to attract the females. A kingfish, on the right, is so pretty; I feel like I have seen small ones in fishtanks.

Razor Surgeon Fish

Moorish Idol

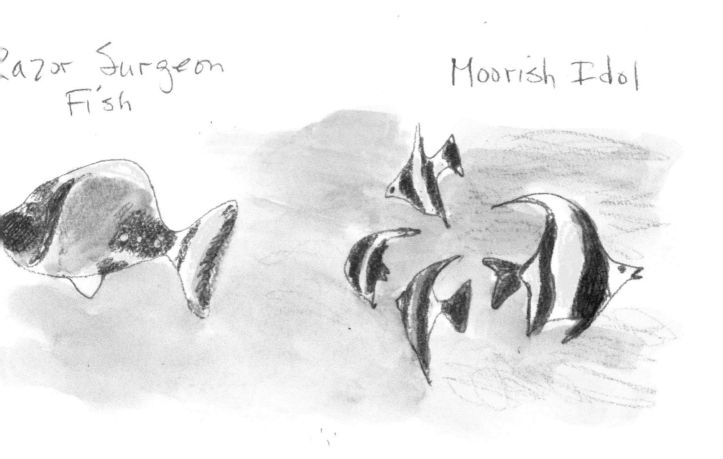

The three dots on a surgeon fish act as a warning that this species is poisonous.
The moorish idol swims past in eye-catching schools.

blue chin
parrot fish

Red Billed
Tropic Bird -
long tail
feathers

so
colorful

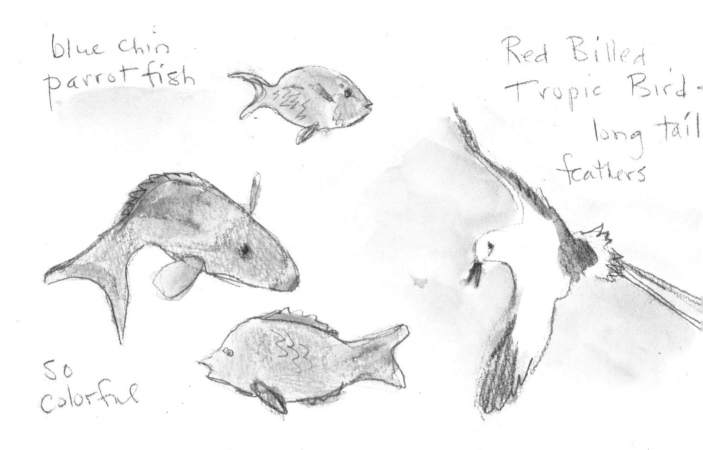

The parrot fish seems like the perfect tropical fish to a northerner like me, colorful in the extreme. The red-billed tropic bird has unbelievably long tail feathers.

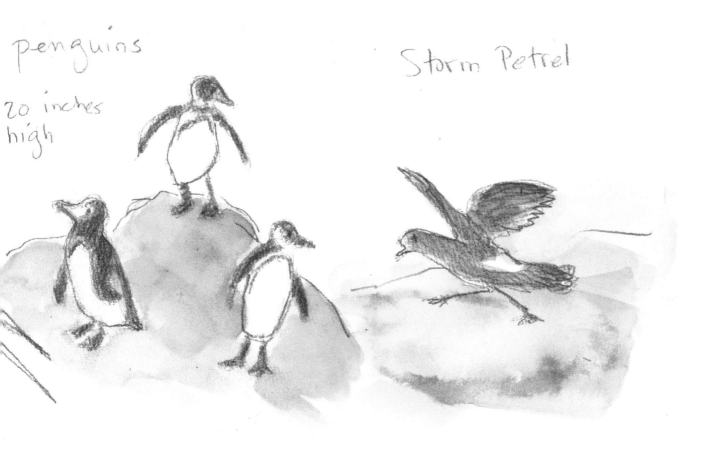

penguins

20 inches
high

Storm Petrel

The small, cute, and friendly penguins are related to those in Antarctica. The cold Humboldt current flows north, right up the coast of Chile. At some time in the past, the penguins followed the current north. The storm petrels are great divers.

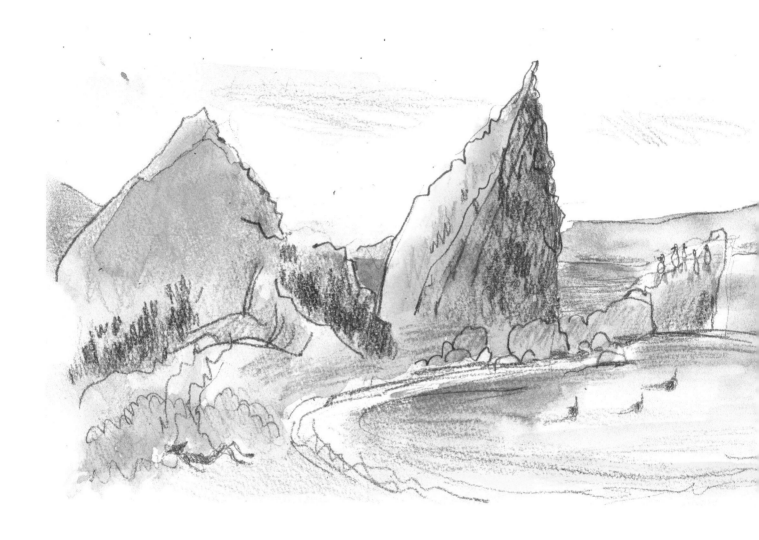

Bartolomé Island is a small one, just off the coast of Santiago Island. The soaring yellow-brown pinnacle is the core of an eroded volcano. See the blue footed boobies clustered on the rock on the right side of the page?

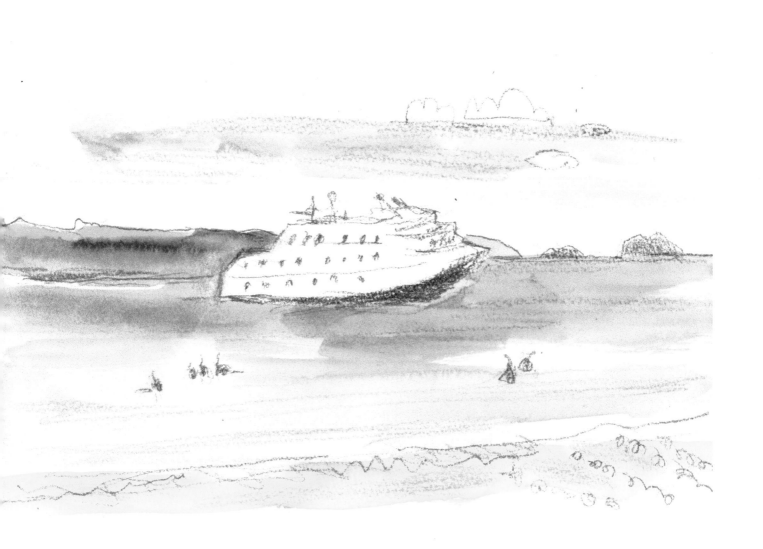

I didn't observe any sea turtles on our voyage, however on the right side of the painting are turtle tracks in the sand. The Endeavor II, a Lindblad National Geographic ship, is awaiting our return just off shore. With our ship family camaraderie, good food, and a comfy bed that rocked us to sleep, the Endeavor did seem like our floating home on the beautiful tropical seas.

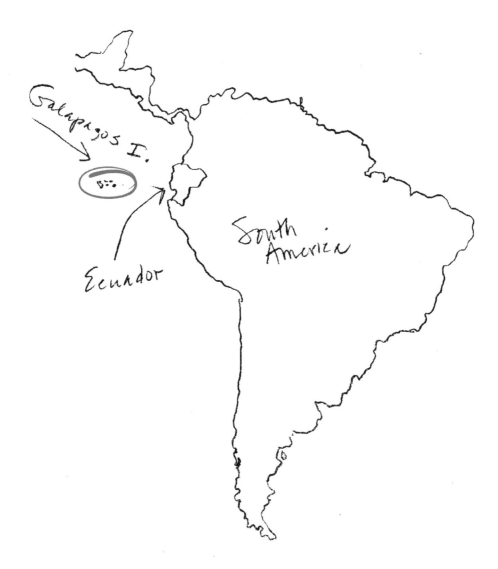

Galapagos I.

Ecuador

South America

For further information about the amazing Galapagos Islands, go to darwinfoundation.org.

To see more of my travels and my art, go to colorfuljourney.art.